Therapy with Sharp Edges
Introduction to Copper Foiling Techniques

Linda Oliveira

PUBLISHED BY WILD TENDRIL, INC.

Therapy with Sharp Edges Introduction to Copper Foiling Techniques

FIRST EDITION

PUBLISHED BY:
WILD TENDRIL, INC.
10700 ANDERSON MILL ROAD STE 110
AUSTIN, TEXAS 78750

www.artisanglass.us
© 2011, WILD TENDRIL, INC. ALL RIGHTS RESERVED

ISBN - 10 0983799326
ISBN - 13 9780983799320

Trademarks: Therapy with Sharp Edges is a trademark of Artisan Stained Glass; Beetle Bits is a registered trademark of Creator's Stained Glass; Morton Portable Glass Shop, and Morton Twister are registered trademarks of Morton Glass Works, Inc.; Kwik-Clean is a registered trademark of the Hoevel Manufacturing company. All other trademarks are the property of their respective owners.

This book is sold as is and without warranty for a specific use or purpose. Stained Glass, like most of life comes with certain risks. By following the instructions or advice in any part of this book, you agree to assume all liability. Under no circumstances shall the author or any of his agents be liable for more than the suggested price of this book.

Table of Contents

Introduction

Welcome to *Therapy with Sharp Edges!* As a studio owner and instructor I am repeatedly asked to recommend a good book for people interested in learning how to create stained glass pieces for themselves. For years I've researched the available offerings and found them lacking in two main areas - Equipment and content. The tools and equipment referenced in many books on stained glass do not take into consideration new techniques and tools we have available. Yes, this is a very old craft and many of the tools used 50 years ago can still generate quality pieces. However, there have been some really great additions to the toolbox that allow more of us to be successful. Tools that fit in our hands better, chemicals that clean better, not to mention...POWER TOOLS!

Secondly, the content of many books I researched explain technique, but not in the context of how to put a project together from start to finish. I include patterns at the back so you can get started right away on your first project. This book is to be **USED** - make notes as needed to remind yourself of tips you've learned, record design ideas - whatever you need for your study of stained glass.

Stained glass is part technique, part experience, and part confidence. This book is a reflection of instruction methods I've found successful in my studio — many of the techniques included have been developed from a commercial studio point of view, and are not "dumbed down" for hobbyists. I use the techniques in this book everyday as I create commissioned works for people across the country, so you can trust they work. I hope you find each session interesting, thorough and repeatable.

If you are fortunate enough to be able to take classes at a commercial studio, use this book as a supplement. Remember: There are many paths to the same destination. Allow this book to serve as your guidebook, noting variations of techniques, tips, comments, and product names that are available near your home.

One last note... Many of you will say (or have actually said it out loud as an excuse...) "I have no artistic abilities whatsoever". And you may really believe that, but stick with me and by the end of this book you'll have a beautiful panel created with your hands, your eye for color and confidence in your techniques. It's all *therapy*, it's just we have sharp edges in our "sessions".

Introduction

Session 1: Tools of the Trade

Throughout the years, stained glass artists have used basically the same tools. I say "basically" as the types of tools are the same but the specific style of some tools has changed drastically – for the better, in my opinion. Every studio owner spends time researching new tools before they add anything to their inventory. Find a studio near your home, you'll be glad you did! They will be a great source of information on new techniques as well as tools and how to use them.

Classes in a group setting will introduce you to tried and true tools and techniques. Your local studio probably works the way I do - we use the tools we sell in our retail shops, and don't carry anything else. That's the best endorsement we can give any tool. There are certainly other tools that work well, and I'm the first to tell anyone who asks, that they should try and use the tools they have before purchasing another just because their instructor uses it. The basic principle is the same, if it does the job, and you're comfortable using it, then it works for you.

Here's a list of the basic tools for a copper foil glass project. Each tool will be explained as it is introduced in upcoming sessions:

- Scoring tool (aka cutter)
- Glass Cutter Oil
- Running Pliers (aka breakers)
- Grozers
- Cork backed ruler
- Bench Brush
- Safety glasses
- Black and silver markers
- Apron
- Copper Foil (7/32" Black Backed is a good all around choice)
- Burnisher
- Glass Pins (5/8" Steel headed push pins)
- Layout Guides
- Layout board (Homasote or a ceiling tile)
- Soldering Iron
- Soldering Iron Stand
- Phaser (rheostat) or soldering iron with internal temperature control
- Solder (60/40)

- Flux
- Flux brush
- Patina (Solder/Lead and Zinc)
- Finishing Compound (Polish)
- Soft cloth (an old T-shirt works great)
- Rubbing alcohol in a spray bottle
- Tinned Copper Wire (18 gauge)
- Wire cutters
- Needle nose pliers
- Latex gloves

Sundry items that are useful to have in your tool kit:

- Green kitchen scrubby pads or steel wool
- Household sponges cut into 1 inch pieces
- Newspapers
- Shower curtain liner or other plastic sheeting material
- Toothbrush
- Plastic take-out containers (ex. salsa cups)
- Paper towels
- Wooden toothpicks
- Cotton swabs

Optional tools that are handy but not necessary for the beginner, especially if you have a commercial studio nearby that offers studio time by the hour:

- Glass Grinder
- Zinc Miter Saw
- Fume Trap
- Luster brush
- Light Table
- Ring Saw
- Cutting grid

Safety first! Whenever you're cutting glass (that includes scoring, breaking, and grozing) you need to protect your eyes. A good pair of safety glasses is essential to ensure you enjoy working with glass without the inconvenience of going to the emergency room to have glass shards pulled out of your eyes. Closed-toed shoes should be worn anytime you're in the studio. Glass doesn't defy gravity and your

feet should be covered.

Students are always afraid of getting cut, so let's get that out of the way. It's highly unlikely you'll lose a finger working with stained glass. It *is* likely that you'll get an occasional poke, slice, or perhaps a gash, but probably nothing serious.

Most cuts come from flashing – the thin sliver of glass that remains when a break isn't perfectly clean. Flashing is sharp as a razor and cuts without much pain – usually you only realize you've been cut when you see blood. When you see flashing on glass, touch it to the grinder or break it off with grozers. Either way, remove it from the glass as soon as you see it or the next time you see it, you might be bleeding. Small glass chips are always around glass cutting. Keep your work space clear by brushing it with your bench brush after each cut. If you rest your hand on a chip, don't panic, a quick wash will most likely remove the chip.

Session 2: Scoring

Glass is cut by scoring it, then breaking it along the score. Scoring tools come in two main styles; pencil and pistol. I use them interchangeably, but most of my students prefer the pistol-grip cutters. Pistol-grip cutters provide easy maneuverability and are comfortable to cut with for long periods of time. There are even cutter cozies that can be purchased to add soft padding to the cutter. If you suffer from wrist pain (i.e. carpel tunnel or arthritis) you may find adding these cozies allow you to cut for longer periods of time.

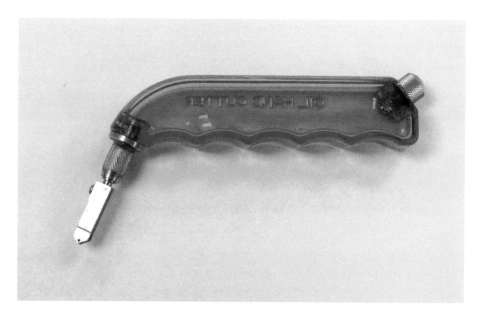

Regardless of the type of scoring tool you chose, the head should be loose enough to turn. Do not tighten the screw on the head of your scoring tool to the point it cannot turn or you'll lose flexibility in cutting curves. If this is a new tool you've just purchased, you should add cutting oil to the reservoir, to keep the head turning smoothly. Oil is added by removing the brass ball on the end of the cutter. No need to fill more than $1/3^{rd}$ of the reservoir – a little goes a long way.

Cutting Basics

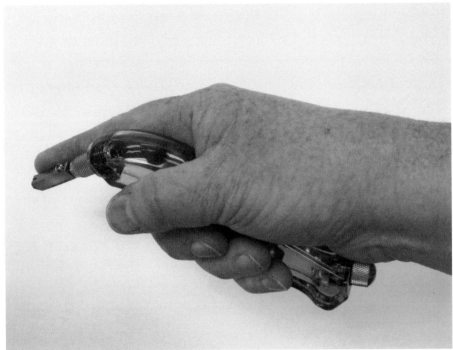

Lay the cutter in your hand as if you were holding, yes, a pistol. Your index finger should extend down to the tip of the cutting head. Your index finger guides the head while you press down on your palm with the correct amount of pressure (more about pressure coming up) to score the glass.

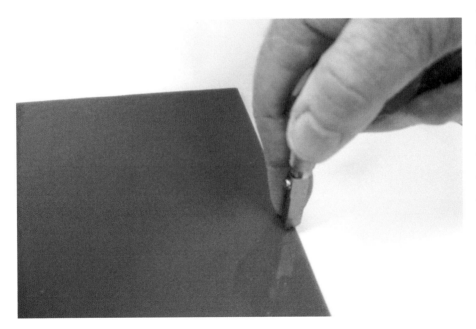

The head of the cutter should start and end each score on the glass. Place the head about 1/16th inch from the edge of the glass. Keeping the head perpendicular to the glass (that would be "straight up and down" in common speak) press down on the cutter as you move it across the glass. Practice varying the amount of pressure and notice the sound each makes. Notice too, the look of a score made with more pressure compared to a score made with less pressure. The perfect score is one that is just enough to break the glass. Tough concept to under-

stand until you practice, so grab some scrap glass and practice! You'll quickly see the difference between a heavy score (one with a lot of pressure on the scoring tool) and a light score.

You can pull it down from the top edge to the bottom, or push it from the bottom edge to the top. Whichever position is most comfortable for you. I prefer pushing it from the bottom to the top – that gives me the most control and allows me to follow my pattern lines, but try it each way to find what's most comfortable for you.

Breaking the Score

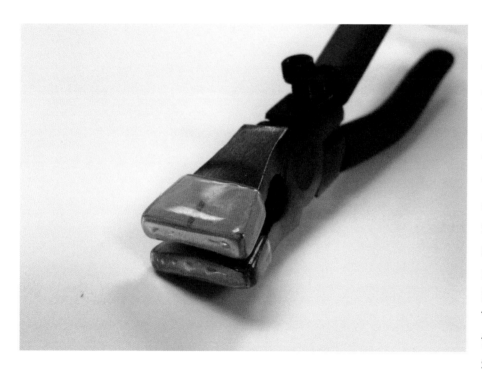

Running pliers have a screw on the top of the curved jaws. Turning the screw widens the mouth of the pliers. When the pliers are closed there should be a small space (approximately 1/8") between the jaws. This space will be filled with the sheet of glass you are going to break in the next step. If they are closed there will be too much pressure on the glass causing it to break in a manner less than desired (i.e. off the score where you intended it to break). You only have to set the spacing once, then forget about it, unless you use drastically different thicknesses of glass (unlikely at this point of your glass cutting career).

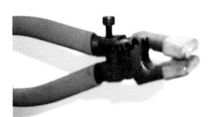

Notice how the jaws of the Running pliers are curved. These curved jaws work together to put pressure on either side of the score causing it to break.

Position the line on top of your Running pliers over the score you just made, near the edge of the glass and press. The glass should break in two clean pieces.

Now try cutting a curve. Same technique as a straight line, but this time, score an "S" shape from one edge of the glass to the other.

Notice in the photo how the Running pliers are positioned on the glass at the same angle as the start of the curve and press. The scored curve will "run" from one edge to the other. If it stops, try breaking it from the opposite edge.

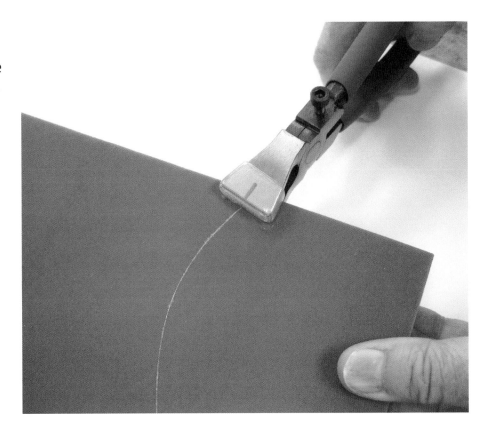

If the score doesn't run completely down the score, breaking your glass into two pieces, use the brass ball on the end of your glass cutter to run the score. **NOTE:** Running the score is a good technique to learn, but understand it can chip the glass. Only use this if the score won't break any other way.

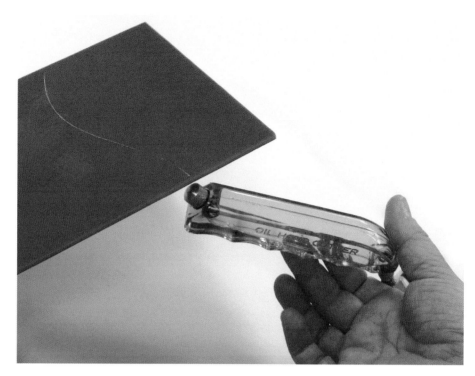

Running the score, means you tap the underside of the score with the brass ball end of your cutter, making it "run" across the glass. Starting where the score stopped running (from your use of the Running Pliers), forcefully tap the underside of the glass along the score. Make sure you have your safety glasses on!

It's important to note here that glass is brittle. A simple statement but important. Cutting a right angle out of paper is simple matter of turning the paper and manipulating the scissors. Cutting a right angle out of glass is nearly impossible. It creates a stress point at the "corner" and will fracture. Always think of your design in components such as lines, arcs, and curves. Although you can't cut glass as you would paper, you can achieve some very complex shapes. Let's start with a circle!

Cutting a Circle

Cutting a circle is not as hard as you think and we'll do it step by step. The concept is to remove all the glass that's not the circle. Trace the bottom of a bottle or other round object onto a piece of scrap glass.

Starting at the edge of the glass (remember to start **on** the glass) score from the

edge to the inside of the circle you just drew. Score an arc approximately 1/5th of the way around the circle, ending your score at the opposite edge of the glass.

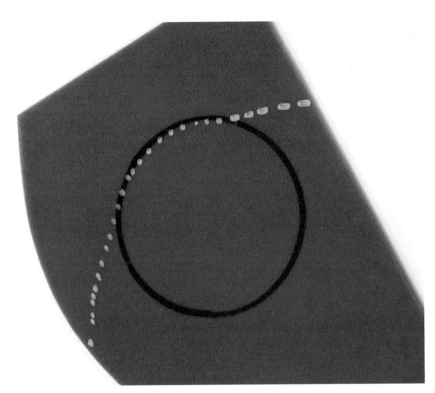

The photograph at the left illustrates this first score. the black line is the circle I want to cut. The dashed silver line represents where my first score will be.

The photograph on the right illustrates all my scores. You don't need to mark them as I did for this illustration, but understand this is how your scores will be made. Note there are no score lines that cross any other score. This is VERY important. Keep your glass focused by not overlapping your scores or double scoring any cut.

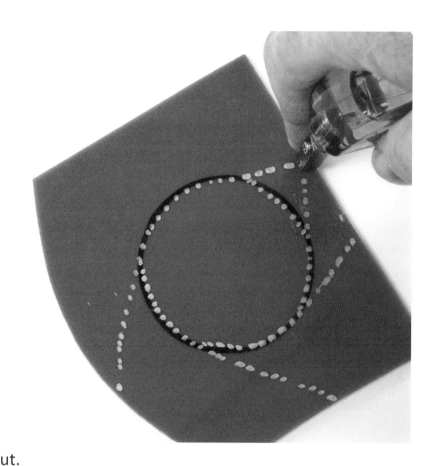

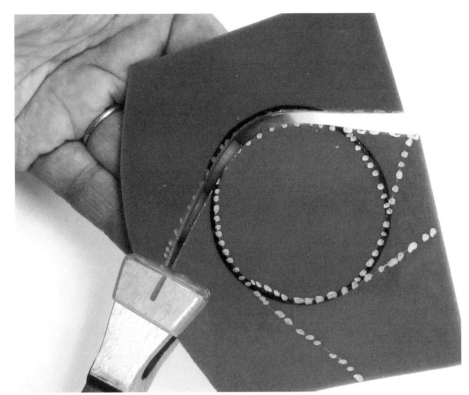

Using your Running Pliers (the pliers with the screw on the top), break the score and repeat the process until you've gone all the way around the circle.

If you have a score that cannot be broken using Running Pliers, it's time to break out (yes I did just make a pun) the grozers. Grozers have a curved lower jaw and a jagged top jaw. I always write a "T" on the top jaw so I can quickly position my grozer without checking which jaw is "top".

Position the grozers perpendicular to the score, and pull your wrist outward. Any small bits can be ground off using a grinder, leaving you with a nice round circle.

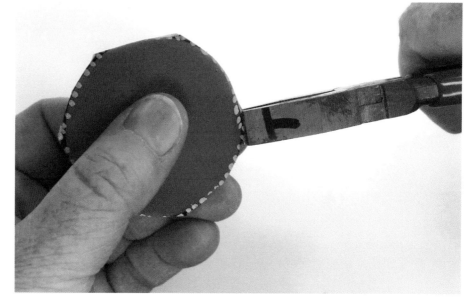

Ok so here is another great place to reinforce safety. When you groze, you will be snapping glass. Sometimes you'll be so excited to be yanking hunks of glass off your patter piece, you'll press, pull, and in general get all tense causing glass pieces to go flying (often into your face). Good thing you're wearing your trusty safety glasses!

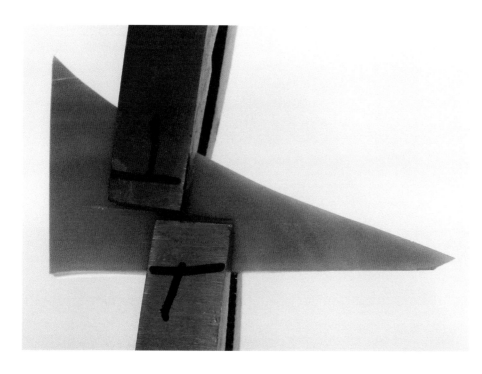

Getting comfortable using grozers will allow you to make breaks you thought impossible, clean up bad breaks, and probably impress your friends! They're a little odd at first, since you grab the glass perpendicular to the score instead of on top of it, but they're *so* effective! For example, if you need to remove 1/8" inch of glass off a piece that's already pretty narrow. Score it then use two pair of Grozers - one on either side of the score to remove the unwanted glass.

Its faster than grinding, easier, and more accurate. Give it a try!

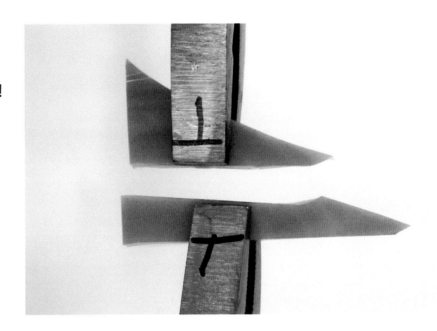

Session 3: Design

Time to choose a design so we can continue our sessions....

The designs included in this book are the same ones I use when teaching classes in the studio. Each represents a varying degree of difficulty. When teaching, I suggest students select the most challenging design that won't keep them awake at night from worry - I'll be there every step of the way to help them succeed. Since we're not in the studio together, I suggest you start with the easiest design and follow it through to the end of this book. Once you've completed this design, start at the beginning again and complete the second. Then tackle the third design. By the time you've completed all three of these designs, you should have a firm grasp of the techniques and can move on to Intermediate level designs and beyond.

When you look at the black and white designs in the back of the book, your first impression is probably one of confusion. You're accustomed to seeing the colored version (aka "cartoon") and probably want to use the same glass or at least the same colors. Let's get this out of the way up front - YOU are the artist, and because you're using a design that many others are using, one of the best ways to make it your own is to use glass that reflects your preferences. Use the colors YOU like and you'll be happy with the results. You just might find the finished piece looks better with the colors you chose!

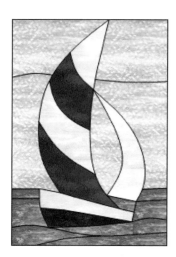

Design 1 (Sailboat) is at the left. Design 2 (Quilted Star) is on the right.

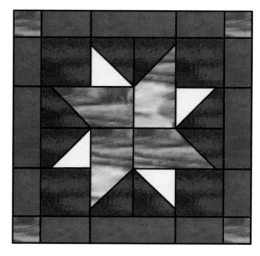

Design 3 (Traditional):

For purposes of demonstration, I've chosen the "Quilted Star" design (Design #2) so you can see how it develops throughout each session.

When you look at the designs in the back of the book, you'll notice the line widths are consistent even though the size of each design might differ. That's because with traditional copper foil techniques you cut the glass so it fits *inside* the lines of the design. The lines represent the width of the copper foil and it's imperative you leave room for it between the pieces. If you don't, you'll end up with a panel that is not square, lopsided, and/or have to do a lot of work as you piece it all together.

Don't limit yourself to these designs. They're provided to get you started. You can design your own or trace a photograph you've taken and create unique designs. For the technical of the readers, line widths are 1/64" on my copper foil designs. This width gives me nice, tight fitting panels.

Glass

There are numerous good sources for information on how art glass is made, and I'm not ready to restate what's been said a gazillion times any differently. If you're interested, next time you're at your computer search a few phrases and you'll find hundreds of articles on the different types of glass how they're made. If you'd like a good understanding of glass, and how it's made check out the Kokomo Glass web site www.kog.com. Kokomo is a fine manufacturer of art glass, and has been doing it for over a hundred years.

I will say this: Art glass (aka Stained Glass) comes in a full array of colors and textures. Take a trip to your local stained glass studio and see all the choices you have in materials. You'll notice the prices of art glass vary by color. Natural elements are used to color glass. That means the more expensive the elements, the more the finished product (in this case, art glass) will cost. There are plenty of selections for you to use in your first piece so don't be put off by the cost of some glass.

Session 3: Design

 Therapy With Sharp Edges - Introdution to Copper Foiling Techniques ©2011 Wild Tendril, Inc.

Session 4: Cutting your Project

Choose your design and purchase your glass. Number every piece of the design (turning it into a "pattern"). As you cut glass, you'll transpose the number of the pattern piece to the glass, making assembly easier. Now it's time to put the techniques you just learned to work!

Clean all the glass you bought using rubbing alcohol and paper towels. Remember to clean from the center of the glass to the edges (and so avoiding any potential sharpness). Remove any stickers (price/manufacturer labels) by soaking them with some rubbing alcohol then using a razor to scrap them off. When all your glass is clean, you're ready to start cutting.

This is one of the places I really rebel against convention so pay attention Grasshopper. Lay your pattern (the design with each piece numbered) on the table. Now, take the first glass selection you want to use and lay it on top of your pattern. If you can easily see the pattern lines through the glass (meaning you're using Transparent or Cathedral glass) then you'll cut the glass using the underlying pattern as your guide.

As I said before, the line weight (thickness) for each design included in this book is sufficient to allow for the copper foil between each piece. If you're making your own designs, and use a computer program, use 1/64" line width. It's a good representation and will allow you to easily see piece definitions. To accommodate the copper foil when you assemble your proj-

ect, you need to cut all your glass on the *inside* of the line. Let's go over that again:

Cut each piece of glass so when placed on the pattern you can see every outline – no glass covers any line of pattern. If you do not follow this advice, you'll have problems assembling. Your pieces won't fit together, because you haven't allowed room for the foil. Additionally, only cut to the line - don't make your pieces too small or you'll have gaps that will have to be filled with solder creating wider-than-desired solder lines. This isn't a deal-breaker, but it's a good goal to work toward. Your first piece is going to have some gaps, and don't worry about it. They really fill in nicely with solder and very few people whose opinions you care about, will point out how one line is wider than another.

Remember to start and stop your score **ON** the glass. You don't need to put your cutter right on the edge; 1/16" inside the edge will still get you a nice break *and* it'll prevent damage to your cutting head. Many people like working with copper foil as it allows them to create smaller, delicate-looking pieces.

Often this requires cutting a small piece of glass even smaller. If you find it difficult to keep the glass on top of the paper pattern try using a few pieces of tape to hold it in place.

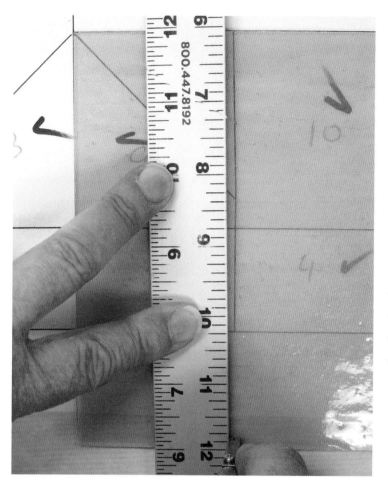

If you're faced with a straight cut, use a cork backed ruler for a nice, straight score. Remember the scoring wheel sits about 1/16" from the edge of the scoring tool. This means you can't just line up the ruler with the line on the pattern - you need to adjust it so you'll score just on the inside of the line. To do this, place the ruler on your glass (that's sitting on top of your pattern). Now, set your cutter against the edge of the ruler and see where the wheel lies in reference to the pattern line.

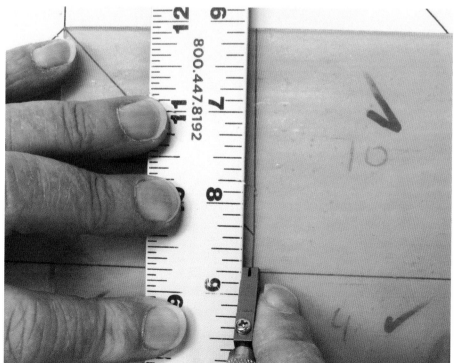

Adjust the ruler so you're cutting wheel is where you want it and then score the glass.

After each piece is cut to fit the pattern *lightly* grind every edge using a grinding stone or with a grinder. This removes any sharp edge that might cut the foil. **TIP:** Don't have a

grinder? No worries - use a grinding stone in a bucket of water. The water reduces the friction of the stone against the glass (which in turn reduces the chance of it overheating and breaking), and it's a nice cheap alternative to a grinder if all you need is to smooth a few edges.

Cut every piece, make sure they fit, number them and set them aside. Don't forget to number the pieces as they're cut and fit or you could have a hard time putting them all together again. Use a Sharpie marker to number your pieces. Use a silver colored marker on dark colored glass and a black marker on light colored glass.

TIP: Use the light table if you can't easily see through the glass. Most studios have a light table you can use during open studio time. You can easily create a light table by placing a lamp under a glass top table if you've got that. Or you can tape your pattern to the window on a sunny day, and holding the glass against it, trace the pattern piece.

If the light table isn't strong enough to allow you see the pattern clearly, trace the piece you need onto a white sheet of paper. Carefully trace the piece using an Extra Fine tip marker.

Did I mention you need to be **CAREFUL** when tracing the pattern pieces? This would be a very good thing to highlight in your copy of this book. If you get heavy-handed with the tracing (making thicker lines) or start "correcting" the design as you trace one or two pieces, then you'll find it very difficult to get everything to fit as expected. Tears and frustration will ensue, so it's just better to be careful and use an **Extra Fine** tip marker. If you don't have one handy, use a pencil or pen that would be better than drawing a big/fat/honking line you'll need to spend extra time grinding.

Cut the pattern piece you just traced – *on the inside of the line*. Put this pattern piece on your glass and trace it with a marker. Then you can cut it as you've been taught – *on the inside of the line*.

Tip: If you have trouble keeping the glass from moving as you cut it on top of your pattern, try using a couple pieces of masking, or painters tape to attach the glass to your design. My students tell me this is a "crazy good idea" so you should try it.

Alternative cutting method

When your design calls for a lot of repeatable cuts; that is, a lot of pieces are the same size and shape, there's an easy way to get accurate and consistent cuts *really* fast - Grid Cutting systems. There are several grid cutting systems on the market; Beetle Bits, Morton Portable Glass Shop, etc. I use the Morton Glass Works system in the studio, but that's just because it was easily available - really...

Design #2 has a lot of rectangles all the same width for the border. This makes it perfect for a rapid-fire approach to cutting the glass! Measure the width of the rectangles - they're all the same width, just different lengths. Set the guides to the width you just measured and start cutting strips of glass. Lay these strips on the pattern and you can quickly cross cut them into the proper size rectangles.

I know this is a very quick overview of how to use a grid system for this type of cutting. Stop by your local stained glass studio and ask for a demonstration. They'll be happy to show you how you can quickly cut squares, rectangles, triangles, diamonds, and more.

Using any of the methods described in this chapter, continue cutting all your pieces before our next session. For that session you'll need copper foil (7/32" Black Back is a good choice), a burnisher, scissors, rubbing alcohol, paper towels, layout guides, and metal-headed pins.

Session 4: Cutting your Project

Session 5: Foiling

Now that all the pieces to your design are cut and fit *within* the pattern lines it's time to wrap each piece with copper foil tape. Solder is used to attach each piece to it's neighboring piece. Solder doesn't stick to glass, but it *will* stick to metal. By wrapping each piece of glass with copper foil tape, you're putting a metal wrapper around the glass, allowing them to be soldered together.

Before you can apply the copper foil tape, you must make sure each piece is clean and all oils are removed from it. The glass you cut using the pistol grip cutter has some oil residue that needs to be removed. Additionally, your hands have oils on them that will prevent the copper foil tape from sticking. Remember, the copper foil tape is the only thing holding your glass together, so if it becomes loose, your pieces will be loose and will not be structurally sound. Soooo... Clean. Clean. Clean. Take each piece of glass and spray it with rubbing alcohol (or acetone, or soap and water) and wipe it with a clean paper towel. This will dry out your hands, for sure, but it will also clean your glass.

There are several methods for applying the copper foil tape: by hand, using a hand tool, and using one of several different types of "machines". I'll demonstrate using each and you can decide which works best for you. In the studio, I invite students to try each method before purchasing another tool. Since this is one dimensional, I've added photographs of each technique so you can get an idea of how each can be applied. I will say this - my students either LOVE or HATE one method or another. The hand tool is the most popular, but again, you'll either love it or hate

it.

Before trying any foiling, open your package of copper foil and remove the outer roll of foil. This has been exposed to air and packaging, and isn't really worth trying to use. In case I forget to tell you later - always keep your copper foil in a zip top bag. It helps to keep the air and moisture away, thus preventing oxidation from happening too soon. Storing it in the house is a good idea too as humidity and heat will shorten copper foil's life expectancy in a big way.

Applying foil by hand

This is the standard, tried and true method. Unroll a bit of foil and lay it face (shiny, copper side) down on the table. Pull off some of the backing, exposing the sticky adhesive (black in this example). Place your first piece of glass on the adhesive, centering it on the foil. Note you place the *edge* of the glass on the adhesive.

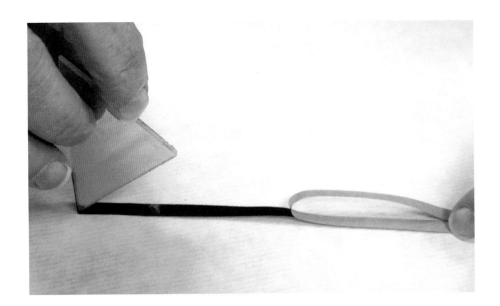

Wrap the foil tap around the entire piece of glass, overlapping it by 1/4". Although for the design I'm doing, it's not important, you should, as a rule, always start/stop your foil on the interior edge of the glass. That means the side of the glass that will **not** be an outside edge to the finished piece. Take a minute and re-read that last sentence, because it's important. The seam is the weakest part of the finished piece, and keeping all the seems toward the interior allows the piece to hold itself together much better.

Cut the foil and fold it onto the face of the glass with your fingers. Your hands are clean, the glass is clean, so the foil should stick very tightly.

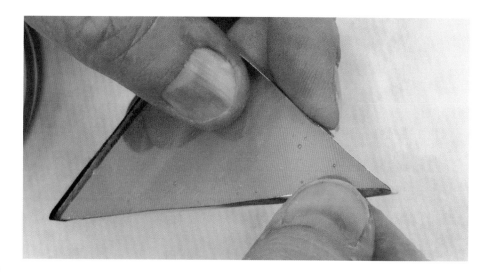

Fold the corners by making "hospital corners". That is, fold one side down and the other on top of it so the result is smooth, flat corner.

A burnishing tool is a piece of plastic that is flat on the sides. You can also use a popcicle stick, wood dowel, or anything similar.

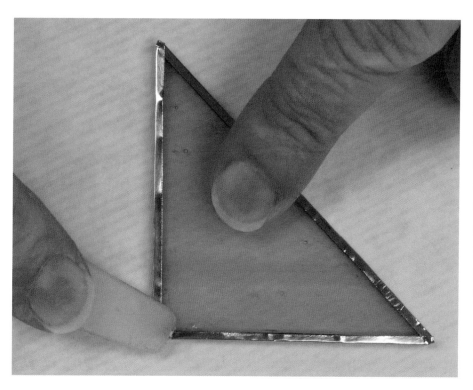

Using your burnishing tool, rub the foil to smooth it down, removing the wrinkles. This also removes air spaces that can cause trouble when you're soldering, by allowing the flux under the foil and loosening it.

Burnish the foil on both sides of the glass, making it as smooth as you can. Ideally, you'll have the same amount on foil folded on each side of the glass. However, occasionally you'll end up with a piece where the foil is applied a little more on one side of the glass than the other.

Let's get this out in the open; the foil is wrapped around the glass to provide a surface onto which solder will adhere. Solder won't stick to glass, but it will stick to metal (i.e. copper foil). No foil, no solder, no structure. A small difference between foil coverage between the top and bottom won't present any issues. A BIG difference (that would be none, or so little you can't even measure it) is a problem and you'll need to correct it.

Corrections can be made easily so nobody needs to panic! With opaque glass (glass you can't see through), a little difference in foil coverage isn't too much of a problem. With transparent (see through) or semi-transparent glass you're going to want to correct the imbalance.

 Hold your newly foiled piece of glass up to the light. If you can see any foil through the glass, you've got an imbalance. As with most everything in life, you've got two choices: Add more foil to the side that seems short-changed, or cut off the excessive foil. Trimming the excessive foil is very easy with a sharp craft knife. Keep the blade fresh and you'll find the foils is trimmed quickly and easily.

If the imbalance is BIG, don't pull off the foil - that's really hard and then you have to clean it again which is just depressing at this point. Instead, add more foil where you need to - that's right, on top of the foil already there. Burnish it down again, and trip where needed, and you're back in the game!

Hand Foiler

This method uses a hand foiling tool, such as the Glastar Handy Foiler. A couple of things are important here. First, these tools fit the size of foil you're using. So if you use several sizes of foil, you need a Handy Foiler for each size. Second, these tools can be difficult to load. Keep the instructions that are printed on the back of the package. You'll refer to them over and over.

Load the foil according to the manufacturer's instructions. There is a slot on the

bottom of the hand foiler - this helps center the foil on the edge of glass. Pull the hand foiler around the glass, overlapping by 1/4". Same rule applies as with the previous method - start and stop the foiling on the side which will be placed toward the inside of the finished panel.

Press the foil against the glass, burnish it and trim any excess as described above.

Foiling Machines

There are many varieties of foiling machines. Some lie flat on the table while others sit upright. As I write over and over again, head over to your local stained glass studio and get a demonstration of any tool you're interested in before you buy something. Some people love 'em and some people hate 'em - be your own judge of what will work best for you.

The basic concept of foiling machines is that they expose the adhesive while pulling the backing away. They have mechanisms in place to help center the foil on the glass. After all that's what we all want - foil centered on the glass.

Again, if you're interested in a foiling tool or machine, head over to your local stained glass studio for a demonstration. They'll be happy to explain each in detail so you can make an informed decision.

Assembling your Design

First thing you'll need is a project board. A project board can be a ceiling tile or a piece of homasote. I prefer homasote but it can be hard to find. The building industry uses it as a sound-reduction material, but I find it works great as a board on which I can assemble my panels. If you can't find it, you can also use a non-asbestos ceiling tile. Some folks like using plywood as it's easily available. This works but it's very hard and you'll need to use horseshoe nails instead of pins.

If you're using a piece of homasote, screw it into a piece of plywood cut to the same size. This will help your homasote last a long time without warping. You'll also need some good 5/8" steel head pins. These are **not** the kind you buy at the office supply or sewing stores. The only place you can get these is from shops that carry stained glass supplies. They have longer pins and metal heads (really important when we get to soldering).

Set up your project board with a pair of straight edges. I like using the Morton Lay-out Guides as they come in a variety of lengths. You can use strips of wood that you secure to your project board with screws. I've done this and it makes a nice, sturdy project board if you have the space to keep it intact. The Layout Guides can be used with pins so they can be removed from the project board and stored sepa-rately.

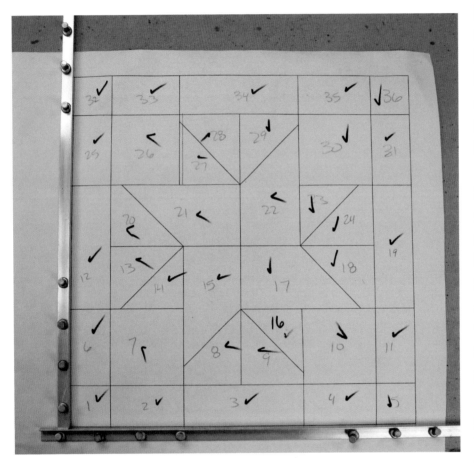

Place your pattern on your project board. Align the layout guides along the bottom and left lines of the pattern.

Insert pins into as many of the lay-out guide pin holes as you can fit onto your proj-ect board. Push them all the way in, using your glazing hammer if necessary. These guides are going to help secure your panel and keep it square so make sure they're tightly attached.

Place your foiled pieces on the pattern and either pin the outside edges with pins or additional layout guides. The end result is your design is secured in place and won't move as you solder it.

NOTE: Always push pins straight into the board. **NEVER** push them on an angle. If you push them on an angle, you're lifting the glass, and your finished piece will have "waves".

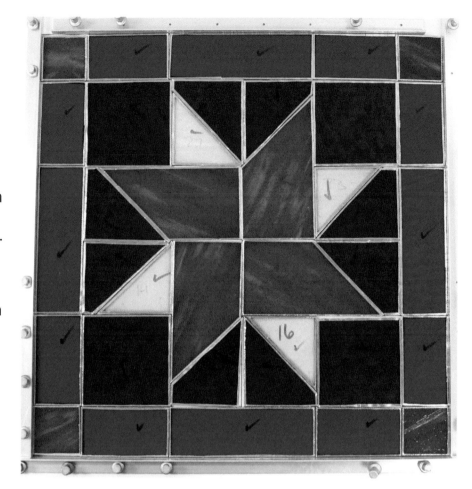

Next session we'll solder everything together so dig up your soldering iron, stand, flux, flux brush, and good quality solder (60/40).

Session 6: Soldering

Soldering is really a fun thing to teach. Soldering copper foil projects is different than soldering lead projects, so if you're moving to copper foil from lead, read on and learn Grasshopper. Plug your soldering iron in and let it heat up. Make sure you've got it in a good stand - saves on the rebuilding costs that become necessary when you burn down the studio (or house)... If you have a soldering iron with an internal temperature control feature (such as a Weller 100 watt iron) you do not need a rheostat (aka "phaser"). However, if you don't know if your iron has internal temperature control or not, plug it into the rheostat to be safe. A steady, consistent temperature will result in a much smoother solder line.

If you're using a rheostat, set it to 70 to start. That's a good, hot temperature and you can adjust it if necessary. How do you know if you need to adjust it? Unwind a good length of solder (10" or so) and press the tip of your heated iron to the end of the solder. If it doesn't melt, crank up the rheostat another 10 degrees. If it melts quicker than you can blink, turn it down. If it melts evenly, then it's just right and leave it alone.

Soldering irons get hot! Between 700 and 1000 degrees Fahrenheit typically. This is hot enough to do some serious damage to your skin so let's take a moment and go over some safety items:

1. First of all, you'll notice your iron has a handle that is plastic, with a lip between it and the metal end. NEVER put any part of your body (hand the most likely part) on the business end of the iron (that would be anything metal). Pay attention when you're soldering and always handle your iron from the cool/plastic side. If you do get burned, take your gloves off and run it under cold water. You'll probably blister but I guess you could look at it like a battle scar you can tell stories about.

2. Wear gloves if you've got them. Most solder is made up of lead and tin, it's not easy to get it into your blood stream in the amounts that will affect you, but I'm getting used to having you around, so let's try and take care of each other. You can buy latex or nitrile gloves at most discount stores. They're cheap and they keep lots of bad things off your hands. I've been teaching for a long time and I know where you put your fingers, so really - keep the gloves on when you solder.

3. Get some air moving in your work space. We're going to be combining solder, with flux and heat, lots of smelly smoke is going to be created and you don't want to inhale any of it. This part is important: DO NOT INHALE THE SMOKE. This is easy to avoid, but repeated inhalation of solder fumes can cause damage to your lungs. And as I said above, I'm starting to get used to having you around, so try and take care of yourself. A simple fan blowing across your work surface is enough. You can also get a fume trap, which pulls the soldering fumes into a charcoal filter. I have these in the studio and I use them when there is only one person soldering in a studio full of people. They really work well. Next time you're at yoru local stained glass studio ask to see how one can work for you.

4. Get your apron on too, because even though solder won't stick to glass, your project board, the floor, or the walls, it will stick to clothing. An apron might get holes in it from the solder, but it'll save your clothes for another day. FYI - Synthetics tend to melt so if your fashion sense doesn't prevent you from wearing synthetics, do it for safety.:-)

It's good practice to solder very soon after you are done foiling (within a week is a good goal). Leaving the foiled pieces exposed to the air will cause the copper to oxidize, leaving a green patina. If you can't solder within a week of foiling, store your foiled pieces in zip-top bags, in a humidity-controlled environment (your house) until you're ready to solder. If you see any oxidation (darkened copper color or green patina) use a wire brush or scrubbing pad to scrape it off. Soldering is much more difficult if you have to deal with oxidation.

Bend and flux

Flux is a corrosive compound that allows metals to be joined. I can go into the scientific mumbo-jumbo about how it removes light surface oxidation caused when heating it, or how it seals the metal from the surface air isolating it from other

types of oxidation, or how it improves the melting temperature and flow of solder. YAWN. What you need to know is this - no flux - no solder. Short and sweet. If you don't apply flux before you solder, your solder will bead up and not attach to the copper foil you just spent hours applying to the glass. This results in things falling apart, so always flux - got it?

There are three (3) main types of flux; liquid, gel, and paste. I prefer the paste to the point its the only thing I carry in my studio. It's lead-free, stays where you put it, and washes off with water (albeit with some scrubbing).

Feel free to use whatever flux you have - I can't see you so I can't complain;-) I'll be using paste flux for my demonstrations.

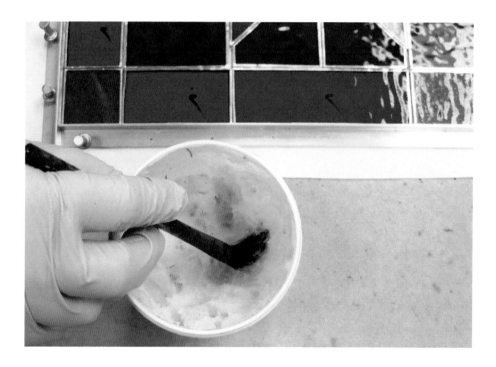

Apply a small amount (aka thin coating) of flux along every seam you're going to solder. **Tip:** Only flux the area you plan to solder in this session. If you're working on a really large panel only flux a portion of it to prevent having to clean it off if you decide to quit.

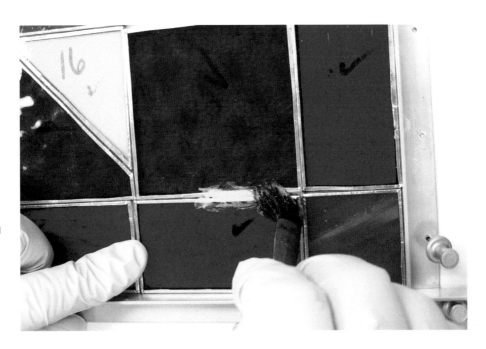

Leaving flux on your copper foil longer than a few hours will result in damage to your foil. Flux is a corrosive and it corrodes, that's its job. Foil left to the wily ways of flux will turn green, slimy and in time, start to deteriorate even further, so just don't leave it on longer than you need to solder.

By now your iron should be nice and hot. Make sure you have a wet sponge near-by. Most stands have a little trough in the front that holds a sponge. Fill the trough with water and some flux remover (if you have it handy) and keep it full. The sponge will be used to clean the iron tip and cool it temporarily. If there is not enough water on the sponge, you just end up with burned sponge.

I mentioned you can use flux remover soap in the sponge. I've found if you add a little bit to the sponge, your iron remains clean and shiny, helping it last a long time. Water works fine too, you'll just need to work a little harder to clean it when you're ready to put it away. I like CJ's flux remover for my sponge, in case you're wondering...

OK - your iron is hot. The sponge is wet and your panel is fluxed. Let's get solder-ing! Grasp your iron as if you were going to shake it's hand. Most people naturally

go for a pencil grip (holding it like you were going to write a letter with it), but it's difficult to get the tip of the iron parallel to the joint you're soldering, because your wrist just doesn't bend that way.

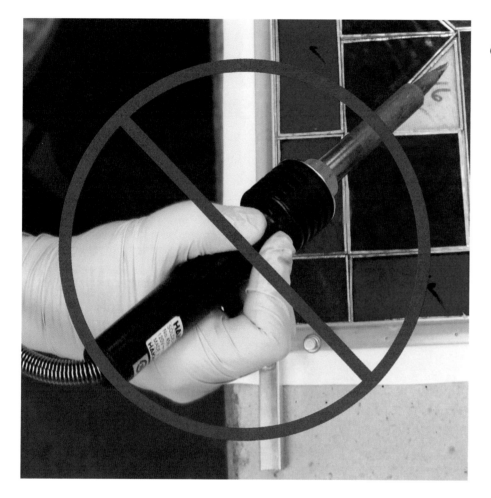

Pencil Grip = Difficult Soldering!

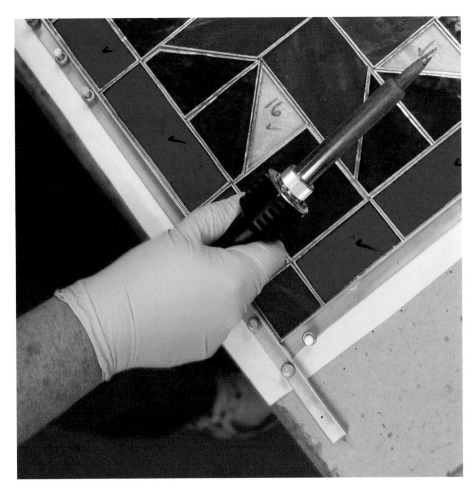

If you hold it like you're shaking hands, you'll get a nice firm grip on the iron and you'll be able to move across your panel very quickly.

The general idea when soldering copper foil projects is to cover all the copper foil. Easy enough. Now to do it well, you'll want to pay attention to the part that follows. Soldering techniques vary greatly and I trust you'll develop a style that results in a quality finished project. Here is a good technique to begin you on your path to smooth, round copper foil seams.

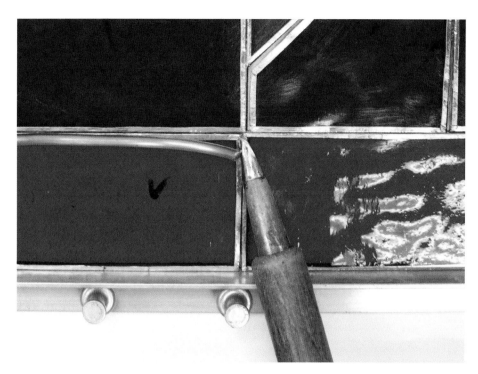

Holding your soldering iron with the tip turned so the largest surface is perpendicular (that would be on it's side) to the panel. Unwind 8 - 10" of solder off the roll. Metal conducts heat so you want space between your hand and the heat. Hold the solder in your non-dominant hand, your soldering iron in your dominant hand.

Another good way to solder is to hold the iron with the widest face up and push the solder onto the face so it flows onto the foil. Try each way to see what's more comfortable for you.

As you start to solder, focus on moving at a steady pace keeping both solder and iron moving

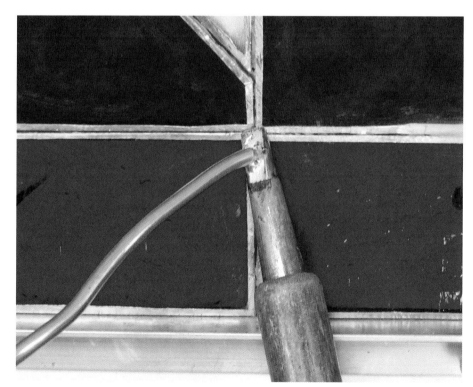

in tandem. It take a little practice to move both hands at the same time in the

same direction, but if you focus on keeping the solder touching the iron you'll be off to a good start.

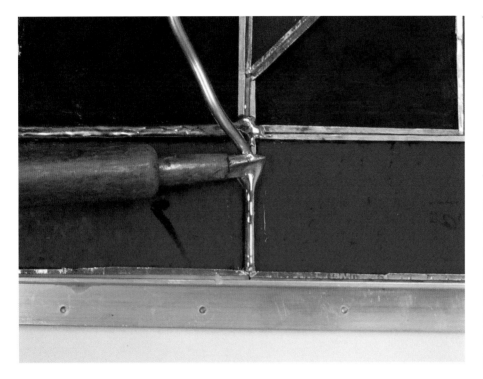

The best solders are smooth and ripple free. To accomplish this, move your iron at a steady pace along the seam. The solder will only attach to the copper foil, so don't worry if you get some on the glass. Don't allow your soldering iron to rest on the glass for more than a second or two.

You're running a pretty hot iron and it can shock the glass causing it to crack (thermal shock in techno-speak) if you keep it on the glass for long.

Good soldering comes with practice. The main idea is to cover all the copper foil with a smooth, rounded bead of solder. If you get lumpy, rough solders, add a bit of flux on top of the area in question and reheat it with your soldering iron. The solder will re-melt and smooth out.

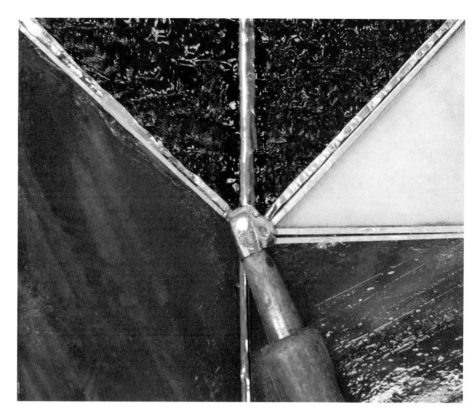

Clean your soldering iron tip by wiping it on the wet sponge you've got in the front of your soldering iron stand every few minutes. This will keep the tip clean of carbon build up (the black stuff) and allow it to maintain a nice, steady temperature.

Solder the first side of your project and allow it to cool for a moment. Then, lightly touch every seam with your gloved hand - anything that catches your glove (sharp, pokey things) needs to be addressed. With a down and up motion, press your iron onto each sharp area all the way down to the glass (you'll learn to "feel" the solder melt down to the glass). Remember, down and up. If it doesn't smooth out, add a bit of flux and then try it again - down and up.

Turn your project over and solder the other side. When both sides are soldered, tin the outside edge. "Tinning" means applying a **thin** (flat) layer of solder. At this point you want to cover all the copper foil so it won't turn green, and oh yea, holds together too;-)

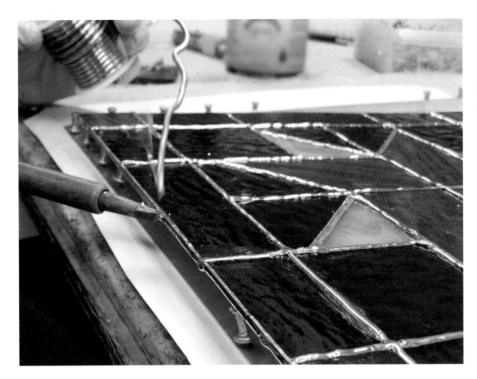

Prop your panel on top of the pins holding the bottom layout guide. This exposes the side of the panel so you can easily tin each side.

Flux the edge of your panel, then pull a small amount of solder onto the iron and run it along the edge. Go around all sides, propping each on the layout guides to allow safe tinning of the edge. Then lay the panel flat on your project board and tin the foil on the top (front) and bottom (back) edges. Make sure all the copper foil is covered with solder. Turn the panel over and check to make sure there is no copper showing.

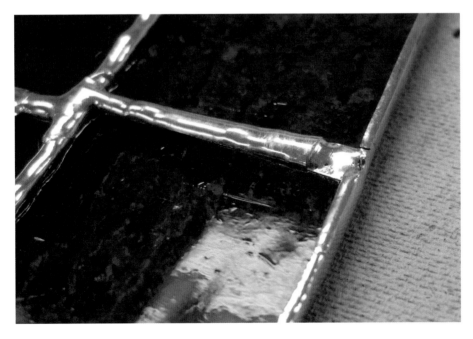

Now your panel is soldered and you can add the hooks. Here again you have choices. Some artists put hooks right on the tinned outer edge. I prefer the safer approach and put zinc frames on every panel I make. The only exception to this would be small sun catchers that have irregular edges. Adding hooks to the tinned outer

edge is the same as adding hooks to the zinc cap, so I'll demonstrate adding a zinc frame and point out the differences when adding the hooks. NOTE: If you're going to add a zinc frame or cap (very thin zinc frame), every solder seam near the edge of your panel must be flattened to allow the zinc to slip over it. Flattening solder seams is a quick process - just press your iron on the solder near the edge of the panel. It'll flatten out faster than you can blink so you can do all of them quickly. Remember to flatten seams on both sides of your pane.

Measuring the Frame

Zinc comes in many sizes from 1/8" cap to 3/4" U channel. Typically sold in 6 foot lengths, it's stronger than the copper foil, yet light, adding strength without measurable weight. I almost always put zinc around my panels. It removes stress on the copper foil seams and allows me flexibility in how I present the finished panel. If you want to add a zinc cap, you'll need to cut the zinc to fit your panel, then solder it in place.

NOTE: Cut your zinc using either a hack saw, or a zinc saw.

You've got 2 choices for your frame; straight corners or mitered corners. Straight corners allow you to insert a hanging piece on the inside edges of the zinc, so all but the hanging loops are hidden. Mitered edges allow you to solder the hanging hoop to the outside of the zinc. Either/or, makes no difference except to you ☺.

For straight edges, measure the width of your panel. For this example let's assume your project is 12" x 16".

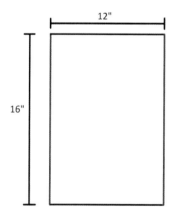

Let's also assume you're using 3/8" zinc for the outside frame. Measure the depth of the channel. For this exercise, the Zinc has a channel depth of 1/8". This is

important in the calculations that follow so don't forget the channel depth.

Ok. The Red lines represent the sides. For straight corners, zinc for these lines will be cut according to the following calculations:

Design length + (zinc width*2) – (zinc channel depth *2)

OR

(16 + ¾) - ¼ = 16 ¾ - ¼ = **16 ½**

The black lines represent the top and bottom pieces. Zinc for these will be cut according to the following calculations:

Design length - (zinc channel depth *2)

OR

12 - ¼ = **11 ¾**

If you want to miter the corners the calculations are as follows:

Design length – (zinc channel depth *2. If you're a zinc frame with a 1/8" channel depth, you'll have the following measurements:

16 - (1/8 *2) = **15 3/4.**

12 - (1/8 *2) = **11 3/4.**

NOTE: These measurements are for the inside corner of the mitre cut.

For those of you with math phobias, here's an easy way to measure and cut your zinc to the perfect size. Using a scrap of zinc (cut 2 inches off the end if you don't have a scrap of zinc the same size as what you're using for this project) you can visually determine the next cut.

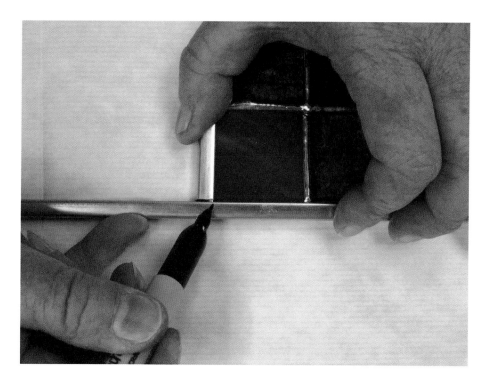

Place the straight edge of the zinc against one corner of the panel, fitting the panel inside the channel of the zinc. Place the scrap of zinc along the joining side.

Make a mark where the two pieces of zinc meet, closest to your panel (the inside edge). This is where you'll cut the zinc at a 45 degree angle. Cut the zinc on the line and place it back on your panel, pinning it in place.

Now move the scrap piece of zinc to the opposite end of the zinc you just cut. Make a mark where the pieces of zinc meet like you did in the last step (and shown in the photograph above). Cut this at a 45 degree angle (away from the panel) and move to the next corner. After you've done this to all four corners, you'll have a perfect fit!

Fit the zinc around your panel and solder the corner seams (of the zinc). Make the corner solders smooth and a little rounded. You don't want to be able to see the cut edges.

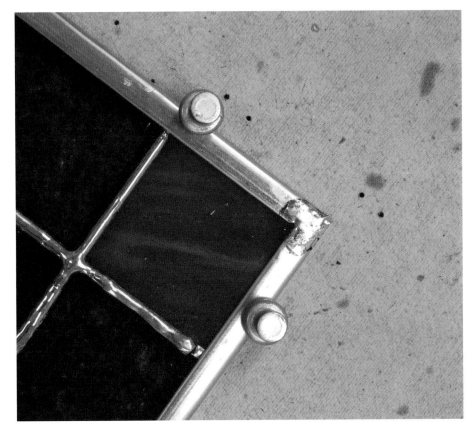

Then you have another choice. Some students like to use the zinc as a frame, keeping the solder lines of the panel from joining the frame. Others like to bring the seams onto the zinc frame.

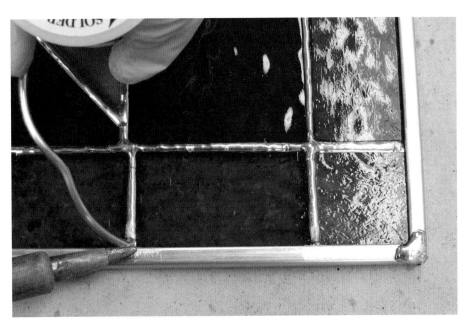

Bringing the seams onto the zinc frame brings the zinc into the design and adds a little more strength. The photograph to the left shows the panel seems being brought onto the zinc frame.

Hooks

If you're planning on hanging your panel, now's a good time to add the hooks. Your soldering iron is hot and you've just been successful soldered your entire panel! There are pre-made hooks you can purchase, but I always show my students how to make the best hooks anywhere. Using a $6 tool, like a Morton Twister, and some tinned copper wire you can make sturdy hooks for any size panel.

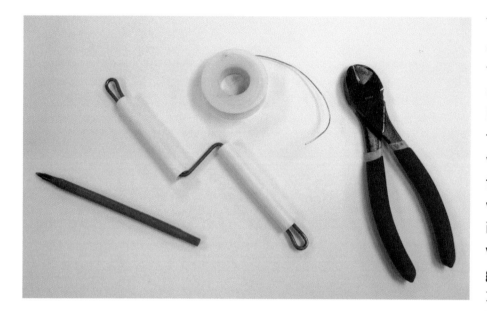

Tinned copper wire comes in many different weights (gauges). The larger the gauge, the thinner the wire. You can use fairly thin wire, and with a little twisting, make it very, very strong. we're going to use some 18 gauge wire for this demonstration. Take a length off the spool. Maybe 4 feet or so. Feed half of the wire through the loop (either loop) on the end of the Morton Twister and join it to the other end of the wire - tying it off on something that won't move. Back away from the tie off point until the wire is taught, and start twisting! When you get a consistent twist to the length of wire you simple untie it, and snip it off the twister.

Now you've got a length of great hook-making wire! To create consistent hoops in your hooks, find a cylindrical object (aka "pen") and wrap the wire around it twice, leaving an end on either side of the hoop you just made.

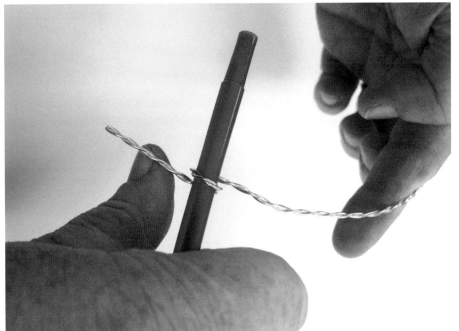

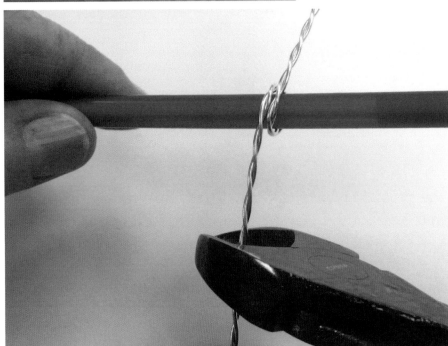

Cut the wire so the ends are about the same length. You don't' need more than about 3/4" or so on each side ("legs") of the hook. The longer the legs, the more you have to solder!

For hooks that will be soldered to the outside of the frame, bend one of the legs in a 90 degree angle, using needle-nosed pliers.

This will go along the Y (vertical) axis of the panel. The straight leg will sit along the X (horizontal) axis.

If you cut your frame with straight edges, you'll bend the legs so the line up together and can fit into the channel of the zinc on the open ends of the frame. I'm demonstrating the more difficult task of soldering the hooks on the outside of the frame.

By soldering the hook onto the corner of the panel you are distributing the weight of the panel by both the X and the Y axis. This will help it

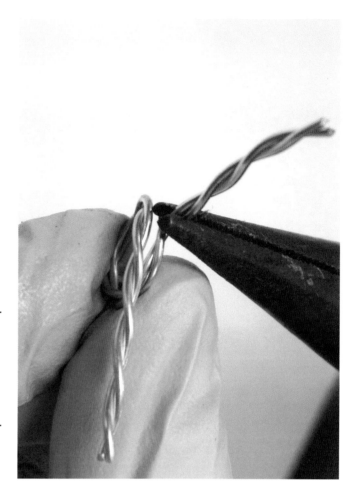

hang for many years without pulling the foil or zinc away from the panel. As a rule I use these types of hooks on every panel I intend to hang and have **never**, had a panel fall because the hook came off.

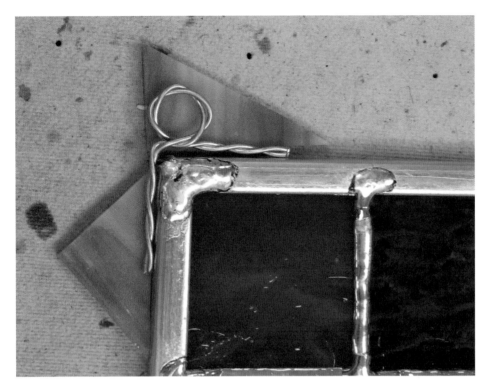

The wire will need to be heated quite a bit before it will accept solder. Flux both the wire and the edge of the panel, remembering that the hook will be soldered on the edge of the panel, not the face.

Here again, are choices for you. You can hold the hook with the needle-nose pliers (use your non-dominant hand to hold this), in position against the zinc frame, or you can place a scrap of glass under the hook to hold it as shown in the photograph above.

Holding the hook with one hand and soldering with the other takes a bit of practice, but is certainly achievable. Start with the glass-under-the-hook trick, then progress to holding the hook with the pliers as you create your second or third panel.

Your hook is in place and fluxed like there is no tomorrow - remember, the hook will need to be heated quite a bit to get it to attach to the zinc. Unroll some solder and hang it over the end of your work table. Melt a little onto the tip of your iron. Use your pliers to keep the hook touching the zinc as you solder. I found placing the pliers on top of the hook, like a weight, and holding it flat against the scrap glass works well.

With the solder side of the tip up, place the soldering iron tip against the wire. As it heats up, gently tip the solder onto the wire. Gravity with take it and move it into the space between the twists and the zinc. You can now release the pliers and tack the other leg of the hook.

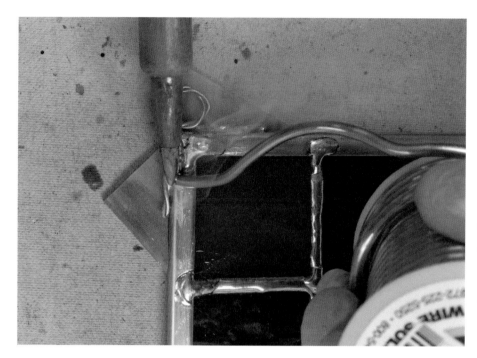

Do the same for the other side of the panel and you're almost done. I recommend you flux the hoop itself and add a bit of solder to it as well. This keeps the hoop from untwisting and really makes the hook strong.

Don't worry about how it looks right now. Your first priority is to attach the hooks and make sure there's nothing sharp that can poke you. When we finish the panel we'll patina these and they'll fade away - promise!

When you've got both hooks on, and there are no sharp, pokey things on either side of the panel, it's time to clean up. Unplug your soldering iron and wipe the tip in the sponge to clean it off. Tin the tip by melting a bit of solder on it and put it back in its stand. The tip is made of metal and all metal oxidizes. Oxidation of your soldering iron tip will prevent it from heating and you'll eventually need to replace it, so taking a few moments to clean it properly pays off.

It'll take about 20 minutes for your iron to cool enough to move it so let's focus on cleaning the panel. Flux is a corrosive, meaning it'll change the appearance of your panel (glass and metal) if you don't remove it. What happens if you don't remove all the flux? Since it's a corrosive, it'll discolor your solder, which means you'll have to scrape it clean before you can patina it as we'll be doing in the next session. It will also leave a residue on the glass that is VERY difficult to remove. It looks like a haze that's confined to certain areas. Not pretty and it takes a ton of elbow grease to remove. Better to just clean the flux off now and avoid more work later. You can do this a number of ways:

1. Put the panel in the sink and use a soft scrub brush and dish soap (Dawn is my favorite) to scrub it clean. Make sure your panel is cool and the water temperature is moderate. If it's too cold/hot you'll shock your glass, cracking pieces, and then we both cry.

2. Spray the whole thing with rubbing alcohol and wipe it with paper towels. You may have to do this twice, but it's quite effective. Use lots of alcohol so it can clean off the flux. Don't skimp on this part or you'll have a greasy residue that will muck with the patina.

3. Use a flux remover, such as Kwik-Clean. Spray it all over the panel and wipe with paper towels. A quick wash with water or rubbing alcohol will no residue remains.

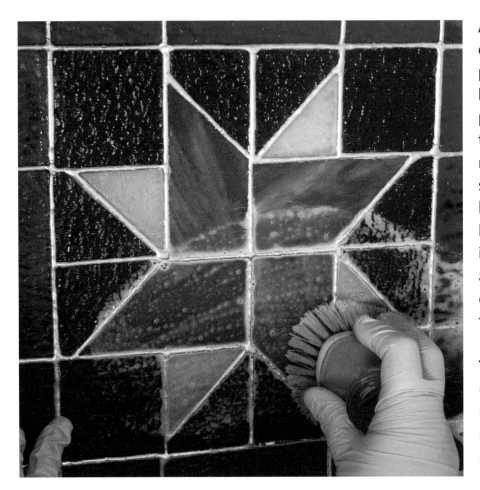

Any of these methods will work - the point is to clean both sides of your panel before setting it aside for our next session. Make sure it's clean before heading home, and that includes removing any numbers or other markings on the glass.

Tip: Use acetone (nail polish remover) to remove the silver marker.

So your panel is now clean - great job! Toss your gloves in the trash, wash your

hands and have a good evening. Your hair smells like solder (somebody had to tell you), so go home and take a shower. If you go to bed without washing your hair, your bedding will stink with the same smell I told you to avoid in the studio. Just another helpful tip from me to you.

Next session we finish the panel! You'll need patina and polish, some small bits of sponge, plastic drop cloth (shower curtain liner works well), a toothbrush and an old t-shirt. Oh and lots and lots of paper towels.

Session 7: Patina & Polish

Your panel is soldered and ready to finish - Yay for you! This is the last session in the process and it goes pretty fast so pay attention. We've got two things left to do; Patina the panel, then polish it so all the metals are shiny and protected.

Patina is an acidic chemical applied to those metals that will naturally patina (change color due to oxidation) anyway - it's a control thing really. If you want it to patina naturally, then you can leave it as is - shiny now, and soon a dull, grayish color. I almost never leave my metals to patina on their own. Not that I'm that much of a control freak... I just think it looks unfinished and prefer to hide my soldering flaws anyway I can (more about this in the section on applying patina). Decide for yourself which shows off your art best and go with it.

Polish is another optional step that I encourage. It protects the glass and the metals from everyday exposure to grime, and air. It creates a layer over everything that helps to keep air out which of course leads to oxidation and it's also similar to waxing your car - it just makes it all shiny.

Patina-ing

Patina is difficult to master. Every piece of metal acts differently and the process is affected by air temperature, humidity, patience and although I can't prove it - I'm pretty sure the amount of caffeine you have in your system.

There are two main types of patina; those that are metal-specific (i.e. solder/lead, or zinc), and single products that work on all types of metal (lead, solder, and zinc). The all-in-one patinas tend to cost more but you only need one product to color all your metals. Patinas that target individual metals are a little harder to work with but they cost less, so check with your local studio and see what they carry/prefer.

Applying patina to the solder works best if you do it very soon after soldering. I generally patina immediately following the cleaning of my panel after it's been soldered. The longer you wait the more oxidation can happen to your metals making the patina process more challenging. Make sure your panel is completely clean (no flux residue) and dry. If you're using a zinc frame, make sure you've scraped it with steel wool, and then wiped it with a paper towel until the towel comes away clean to ensure a good absorption of patina.

To make my patina as dark as I can, I often re-clean my panel using a flux remover such as Kwik-Clean. Just spray 3 pumps of this cleaner (after you shake it up well) to a clean paper towel. Clean one side of the panel, then repeat with a clean paper towel on the other side.

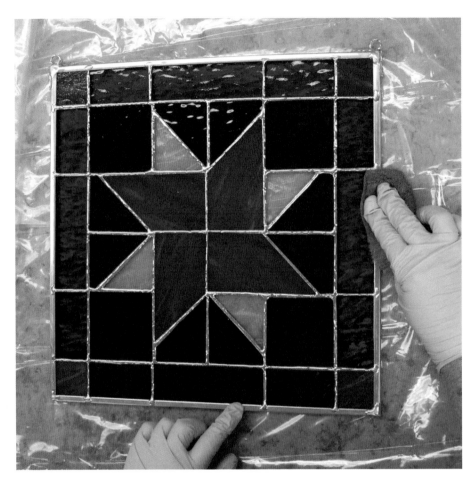

Place your panel on top of a plastic drop cloth or shower curtain liner. The shower curtain liner is easy to wipe clean when you're done. You can also use clean newspaper - a couple of layers thick if you don't have the plastic drop cloth available. Scrape the zinc with extra fine steel wool (size 000), and then clean it with paper towels and a few sprays of Kwik-Clean.

I put my patinas (Patina for Solder and Patina for Zinc) into spray bottles. This allows me to spray just enough patina where I want it, with little waste. You can also pour some Patina for Solder into a small plastic or glass cup (condiment containers from your favorite take-out restaurant work great). NEVER use the patina straight out of the bottle. When you apply patina using a sponge, the sponge is going to get dirty, any dirt that gets into the bottle causes the patina to be contaminated, making it less potent and your results could be less than desired. When you're done with the patina you've poured into a small plastic or glass cup, you'll empty it onto some paper towels to be thrown away.

Spray patina onto your panel, or dip a small piece of sponge into the patina you've poured into a small container - make sure it's really wet! Rub it over the solder and you'll see immediate results - the solder turn darker. Cover all the solder on one side of your panel, then grab a toothbrush (the stiffer the bristles the better), and brush the patina all over your solder lines. On larger panels you can use a floor-type scrub brush. In either case, make sure the brush is clean and used only for patina applications.

If you're using a patina that is blended for all types of metal you can apply it to both the zinc and solder at the same time. Keep dipping your sponge into the patina so it stays wet. Excessive application is ok because we'll wipe it off quickly.

On larger panels, or if you prefer to use separate patinas for the solder and the zinc, patina all the solder lines first. Then apply a patina for Zinc on the frame.

After brushing on the patina, let it set for a few minutes (3-4) then flip it over and apply patina to the other side. After another 3-4 minutes rinse the panel under cold water. Spray the entire side with a liberal dose of a commercial flux/patina remover and wash it again with cold water. Dry it off with some clean paper towels.

A mix of baking soda and water (2 Tablespoons of baking soda to 1 quart of water) in a spray bottle is a good substitute for commercial flux/patina removers. Keep a spray bottle of this around and you can use it instead of the commercial blends if you prefer.

NOTE: Patina works best when the metal is clean and warm, don't try to get a nice patina working in the garage during a snowstorm!

IMPORTANT NOTE: Don't allow the patina to completely dry before you head to the sink. If patina stays on your glass for long it will leave a residue that is really, really hard to remove, so let's just avoid that all together.

After you do all the solder lines, patina the zinc but let this patina set for 5-6 minutes before cleaning. Make sure the zinc is clean, dry and had a good scraping from steel wool before you patina.

I guess this is a good time to tell you there's more than just black patina - you can use copper, brown or antique green (although this is hard to find and takes additional steps). Each of these patinas require additional preparation and application steps which I'll leave for an intermediate session.

Polish

Now your panel is now technically complete. Time to polish it so your friends can heap well-deserved glory and admiration on you when they see it hanging in all its glory. Using a carnauba wax-based finishing compound (that's stained glass speak for "polish" made specifically for stained glass) you are now ready for the final step. **TIP:** Don't try using car polish on your panel. It might have carnauba wax in it, but it doesn't give the same results - I've tried it.

Shake the bottle very well as it separates upon standing. Pull on a fresh pair of gloves and you're ready to go.

Pour a small amount of polish into a gloved hand and rub your hands together. Now rub it all over your panel. Glass. Metals. Everything. A thin coat is all you need. More only causes a longer dry time and is harder to remove.

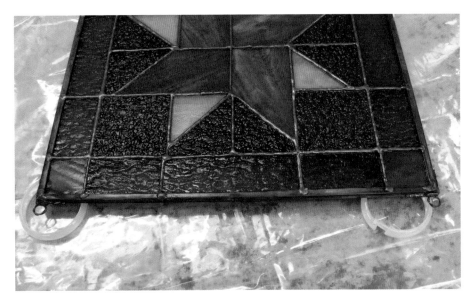

Flip your panel over and apply polish to that side as well. I like to prop one edge of my panel on something that will allow air to get to the underside. Shower curtain hooks work great (and I got a deal on them when I bought the shower curtain!) It will take about 20 minutes to dry to the point it looks matte (hazy/white), which is the stage we're waiting for before removing it. Good time to clean up.

When the polish is dry, use an small scrap of an old cotton t-shirt and buff the polish off both sides of the panel.

Buffing across the seams creates a very shiny result, and who doesn't like shiny things?.

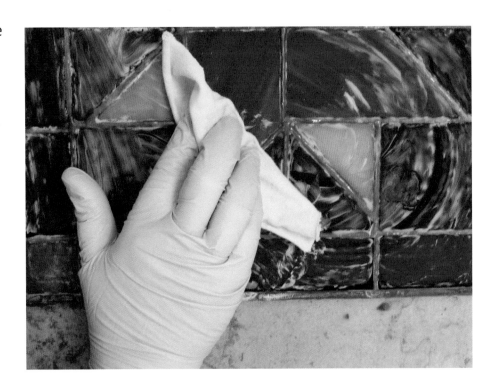

For larger projects, you can use a luster brush attachment for a power drill to get a very fast finish to this process. Check with your local stained glass shop for a demonstration of how a luster brush works - you'll be surprised how quickly it can polish a panel.

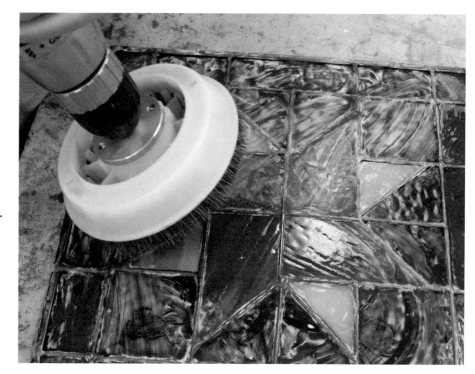

Your panel is now bright and shiny! You may notice some areas where the brushing and polishing may not have gotten all the excess polish out. A clean toothbrush and cotton swabs are great for these areas. Clean wooden toothpicks also do a

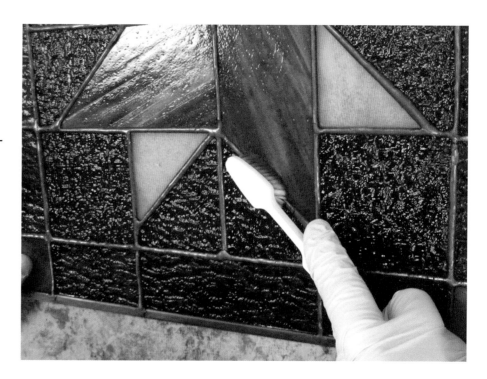

great job of getting into small spaces where the polish may have settled.

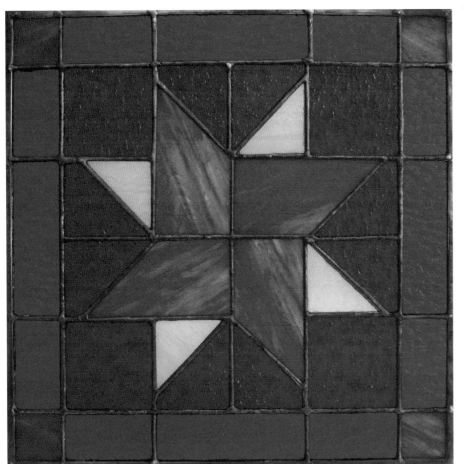

That's it! You're done. Great job!

A few brief words from the Author....

After 30 years of quilting I needed an outlet that provided a challenge yet held my interest in color, texture and yes, made me sweat a bit in the process of creating something I could admire for many years. With glass, I've found my match. A single piece of art glass can be shiny, smooth, rough, and seems to have a mind of it's own.

This book is a compilation of the techniques I've learned, created or fell into by chance or dumb luck. It's about conveying centuries-old techniques in a manner that instills confidence, joy, and humor. None of it would have been possible without the community of glass artists and friends I'm glad keep coming to the studio each day. They push me to be better than I was yesterday, easing their concerns over rough solders, glass that just won't behave and finished pieces that don't fit their intended spaces. Keep it coming!

I'm Linda Oliveira and I'm addicted to glass. But, I **am** in therapy. It's all Therapy with Sharp Edges you know...

Acknowledgements

My deep gratitude to Karen Tarlow for her photographic skills, wit and understanding of the concepts I'm trying to convey. When I hear her laugh from her studio next door, I know things are going to be better than all right. She created the cover for this book as well as took every photograph. Boy, do I owe you!

Proof reading and editing are tasks best done by detail-minded people who either really like you or owe you a huge debt. Luckily, I met Jenny Ehrlich who apparently likes me enough to spend hours and hours reading, commenting and suggesting ways to make each draft that much better. I am truly fortunate to have you on the team - thank you!

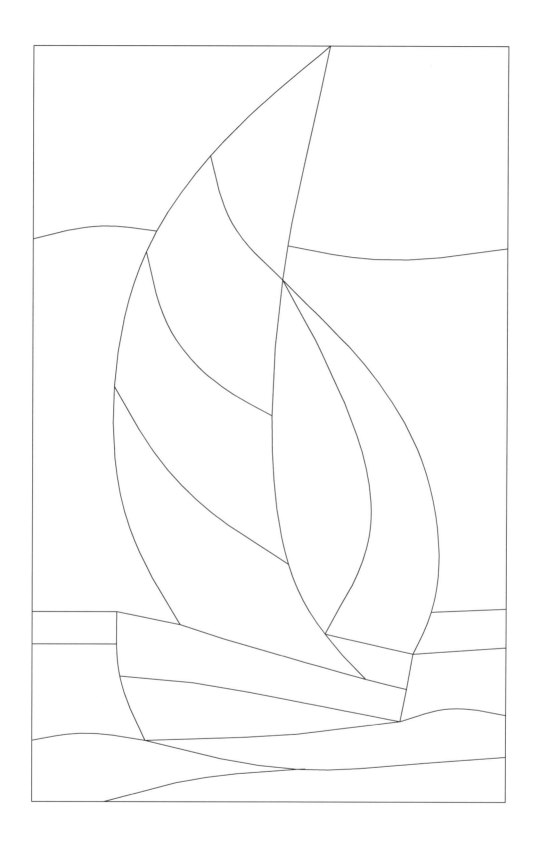

Enlarge to 11" x 17"

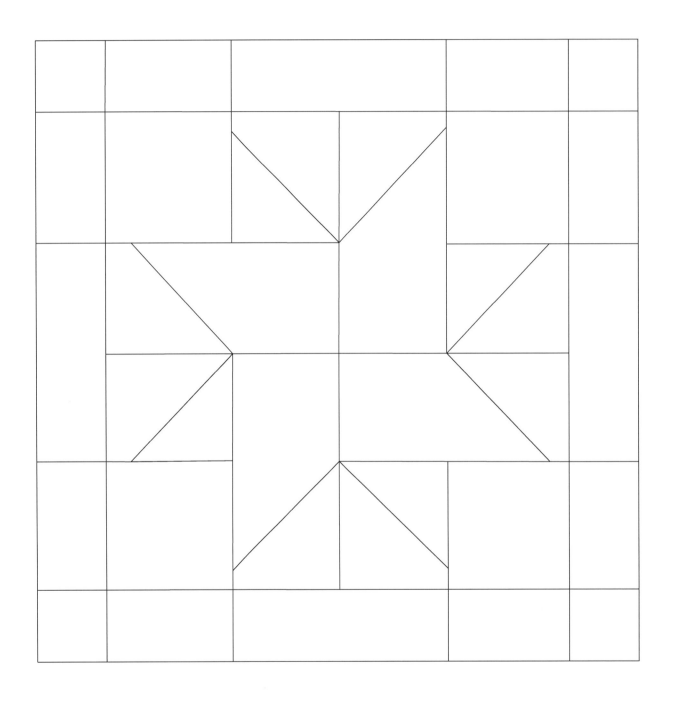

Enlarge to 13" x 13"

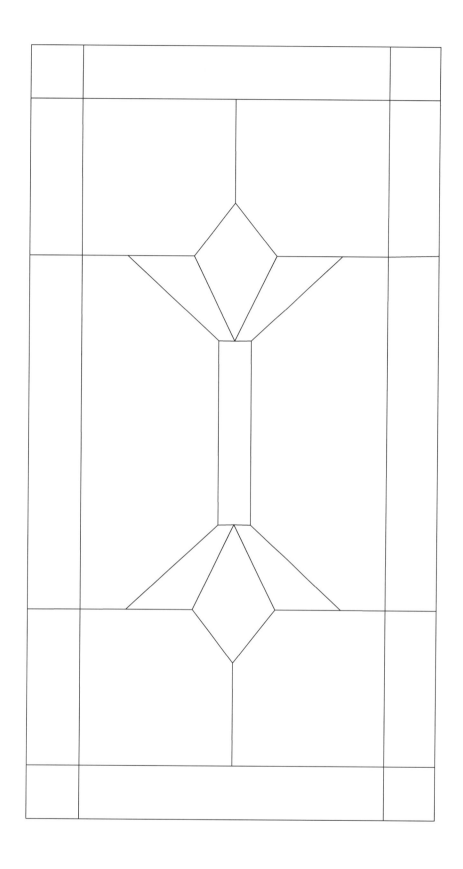

Enlarge to 9" x 16.5"

16954766R00045

Printed in Poland
by Amazon Fulfillment
Poland Sp. z o.o., Wrocław